Monica Rich Kosann

THE FINE ART OF FAMILY

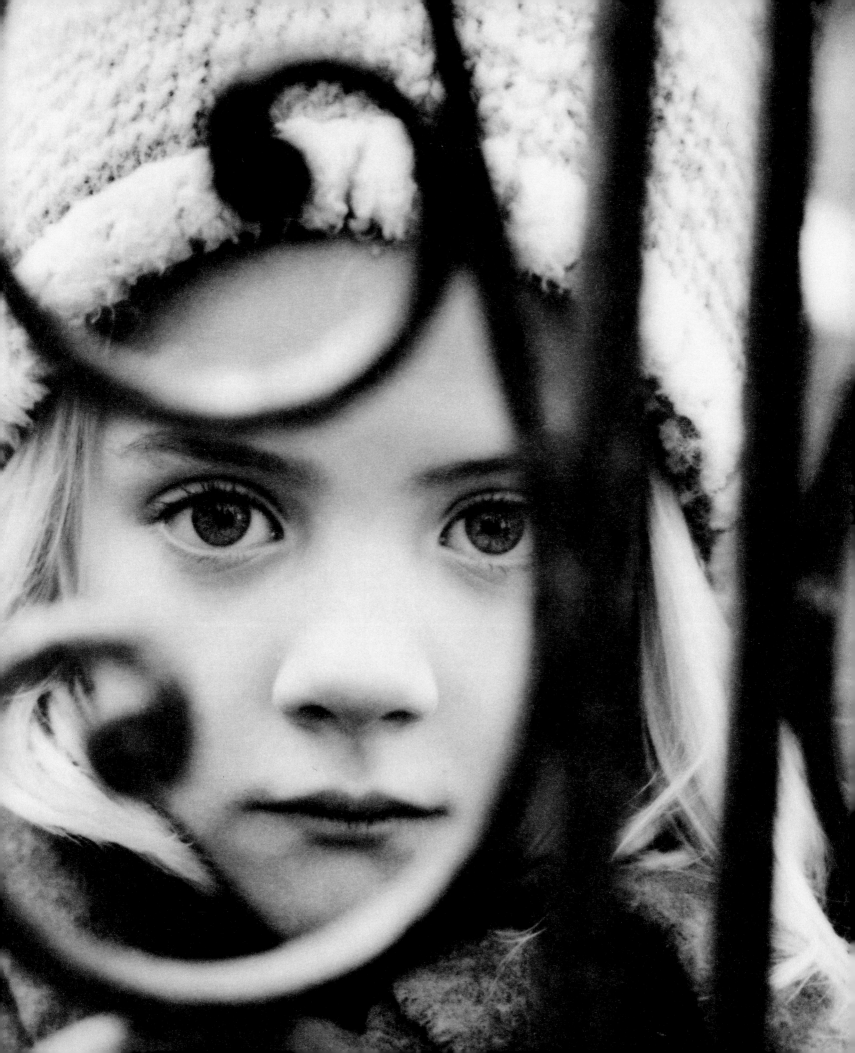

Monica Rich Kosann

THE FINE ART OF FAMILY

I WOULD LIKE TO THANK all the children and families who allowed
me to capture a moment of their everyday lives.

Images and text copyright © 2004 by Monica Rich Kosann.
All rights reserved.

M and *Fine Art of Family* are trademarks of
Monica Rich Kosann.

ISBN 0-9744202-0-4

Published by
MRK Fine Arts LLC
P.O. Box 478
New Canaan, Connecticut 06840
www.mrkphoto.com

Frontispiece: *Iron Gate*

This book has been typeset in Adobe Caslon with
additional accents in Arabesque Ornaments Two and
Rococo Ornaments One.

Designed by Ed Marquand
 with assistance by Zach Hooker
Separations by iocolor, Seattle
Produced by Marquand Books, Inc., Seattle
 www.marquand.com
Printed and bound by CS Graphics Pte., Ltd., Singapore

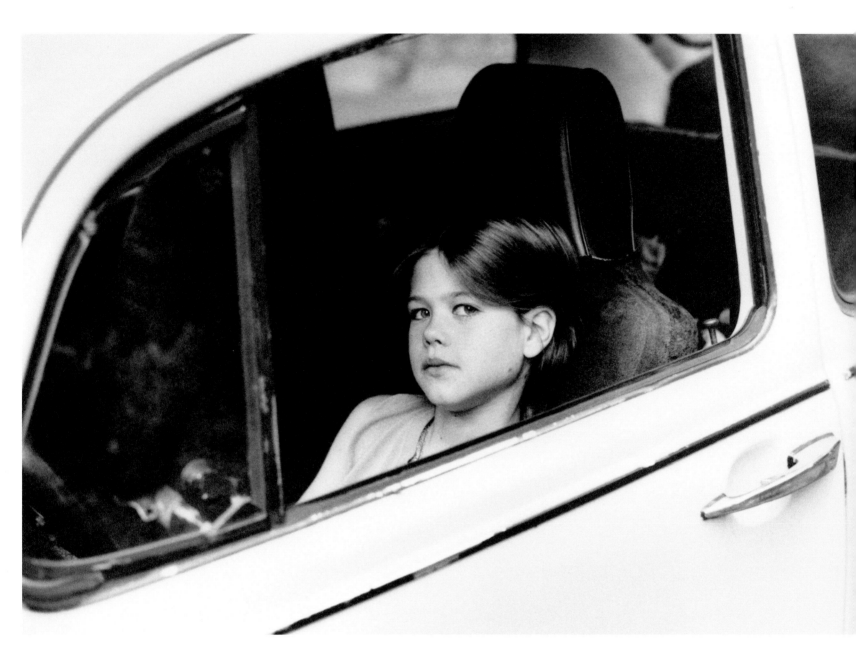

Aiden

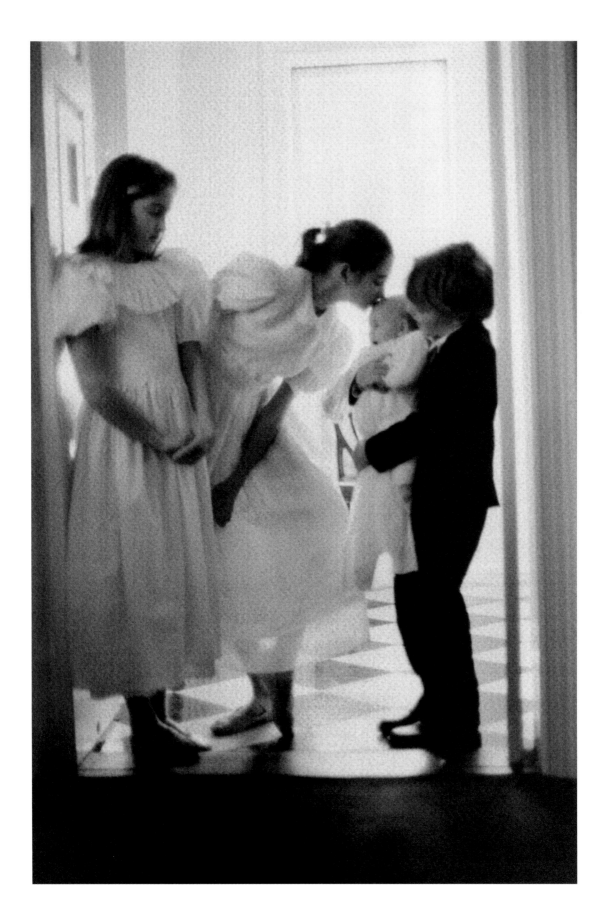

Ode to Gertrude

The Fine Art of Family

*F*AMILY IS WHAT BINDS US TOGETHER. It is what we can depend on. Whatever our place in history, family is what unites us to preceding and succeeding generations.

For over fifteen years, I have been professionally photographing families, children, and adults. These are not "family portraits" in any conventional sense. That is, I don't show up with my camera on ceremonial occasions and ask parents and kids to smile into the lens. Instead, I go in search of their real lives—children playing together, parents and children caught in a moment of perfect communication.

Anyone working with a camera is likely to be influenced by many artists. In my own work, the greatest inspiration comes from the turn-of-the century photographer Gertrude Käsebier. As Käsebier once said, her portraits were never meant to be "maps of faces." Her goal was to "make likenesses that are biographies, to bring out in each photograph the essential personality that is variously called temperament, soul, humanity." Whether photographing children or adults, I am looking for the same elements that Käsebier found so essential. I believe they are some of the important elements that ultimately define our sense of "family."

Not surprisingly, I find this is far easier to achieve if I come to people's homes or the places where they feel most comfortable. Once there, I try to find a time when they are impulsively expressive. Whether it is the tender embrace between a mother and infant or an adult's lapse into reflective solitude—either can be just as telling. My task is to have my camera ready when *the moment* arrives. During our sessions, I endeavor to gain some insight into my subject, or the interaction of a family, so that I might recognize that moment and create an image where their self-expression truly reveals itself.

This approach is especially important when I am photographing children. They have great natural curiosity. Though some are shy at first, they quickly discover that I enjoy playing as much as they do. But oftentimes, I become the forgotten observer—an invisible bystander who just happens to carry a camera. Most are not even aware when the shutter clicks and the picture is taken.

The images to follow are as varied as the people I photograph, but their focus is that single theme which I think of as *"The Fine Art of Family."*

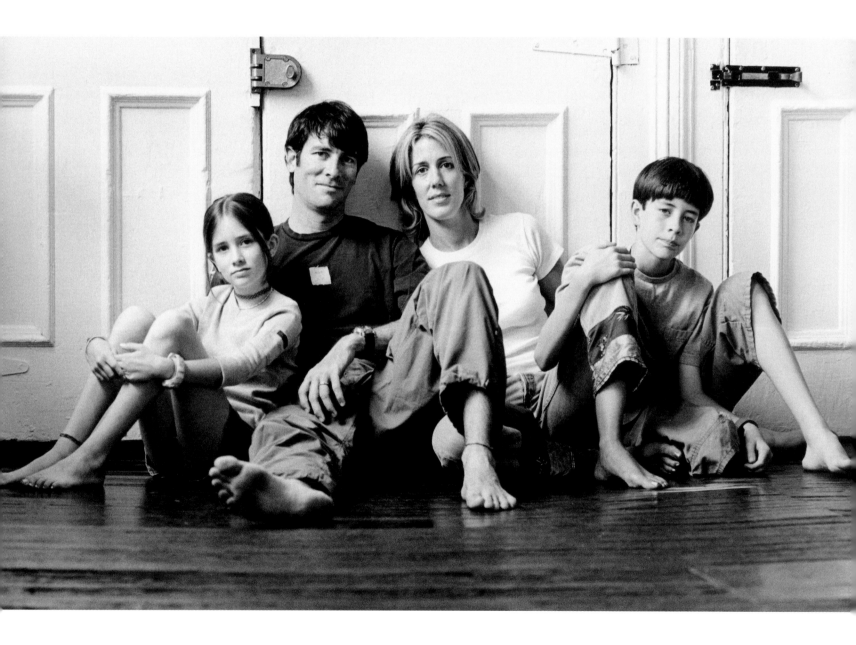

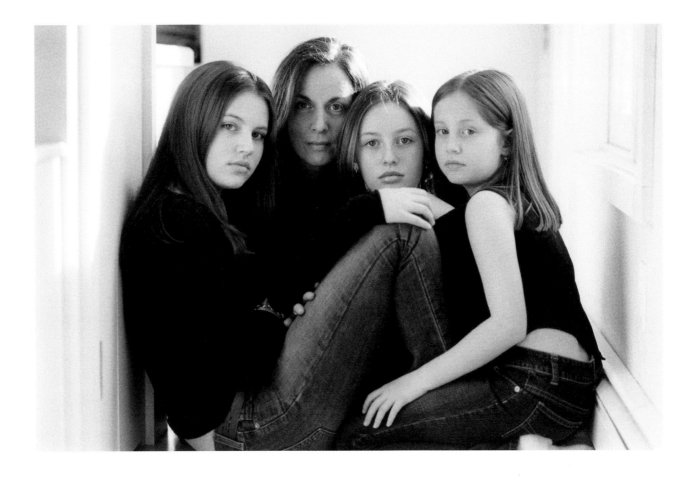

Soho

Bunting

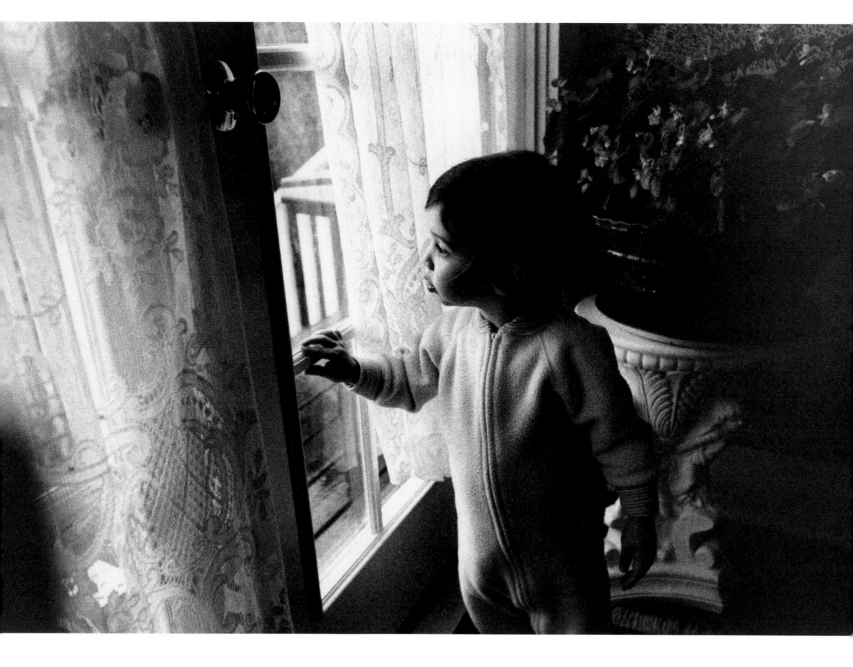

New Arrival

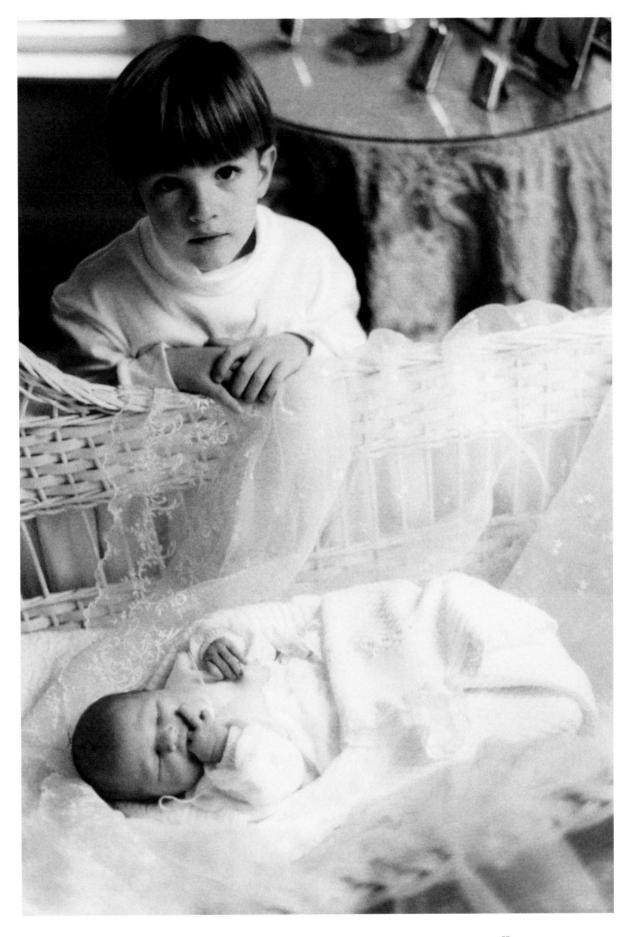

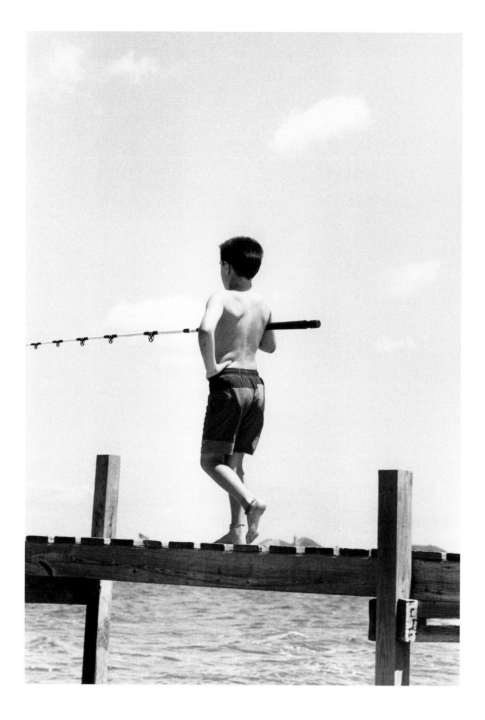

Gone Fishing

A Summer Day

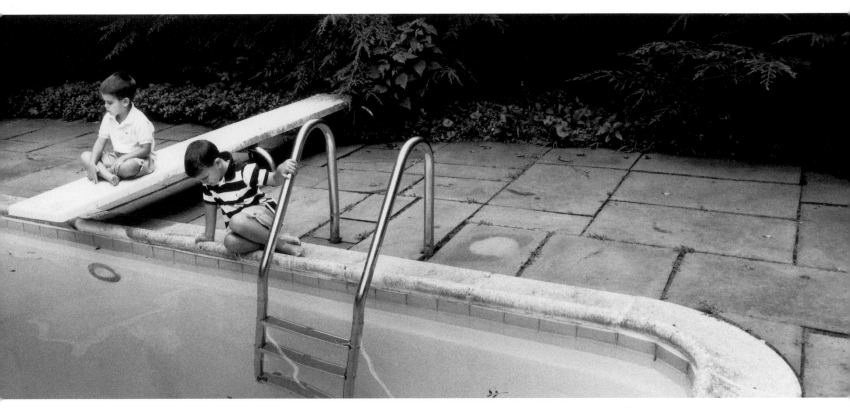

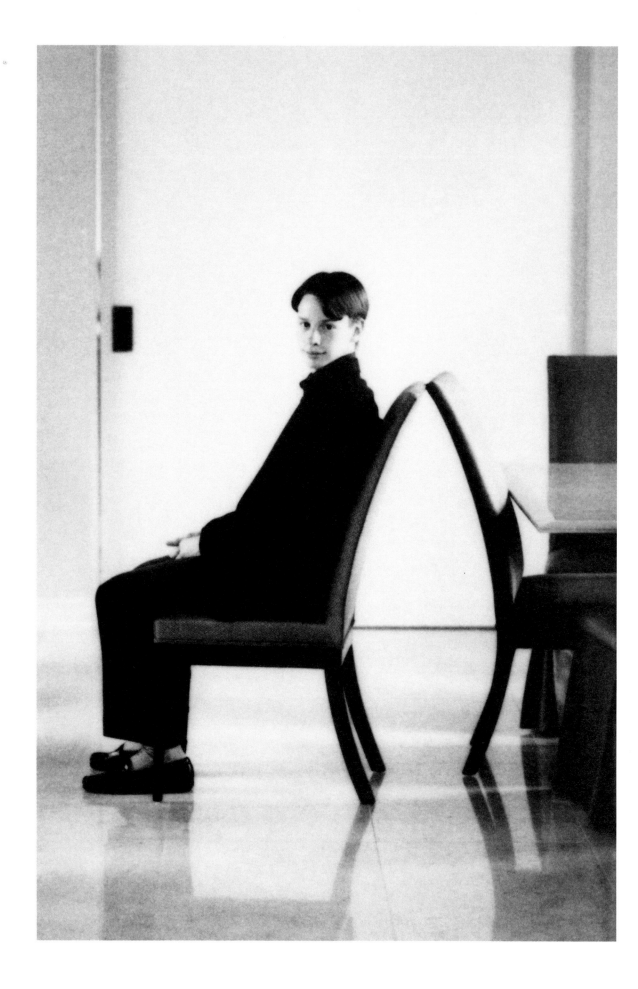

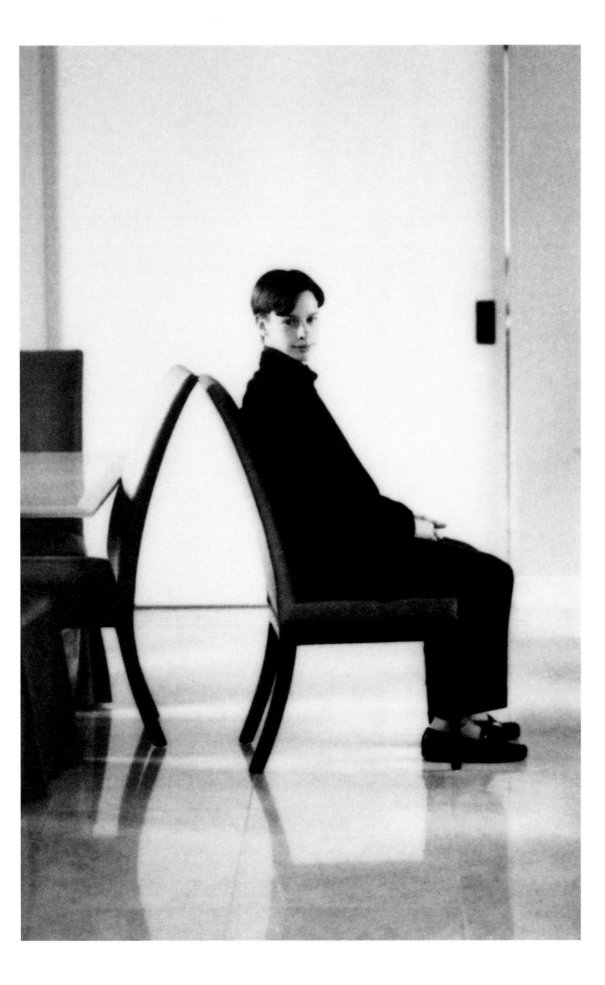

Young Man in Chair

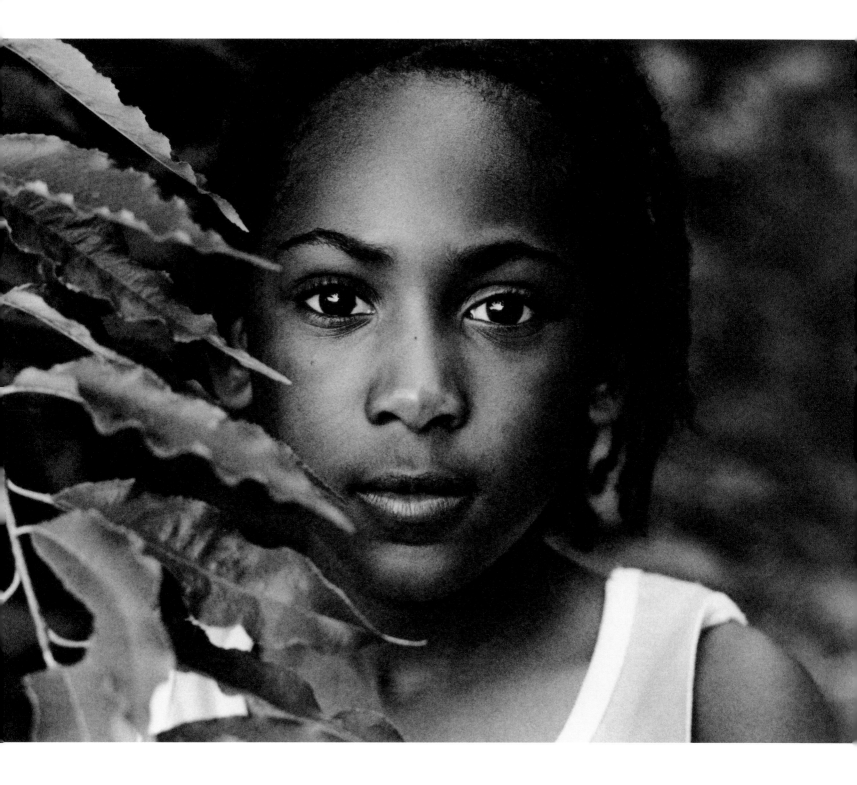

Portrait of Lily

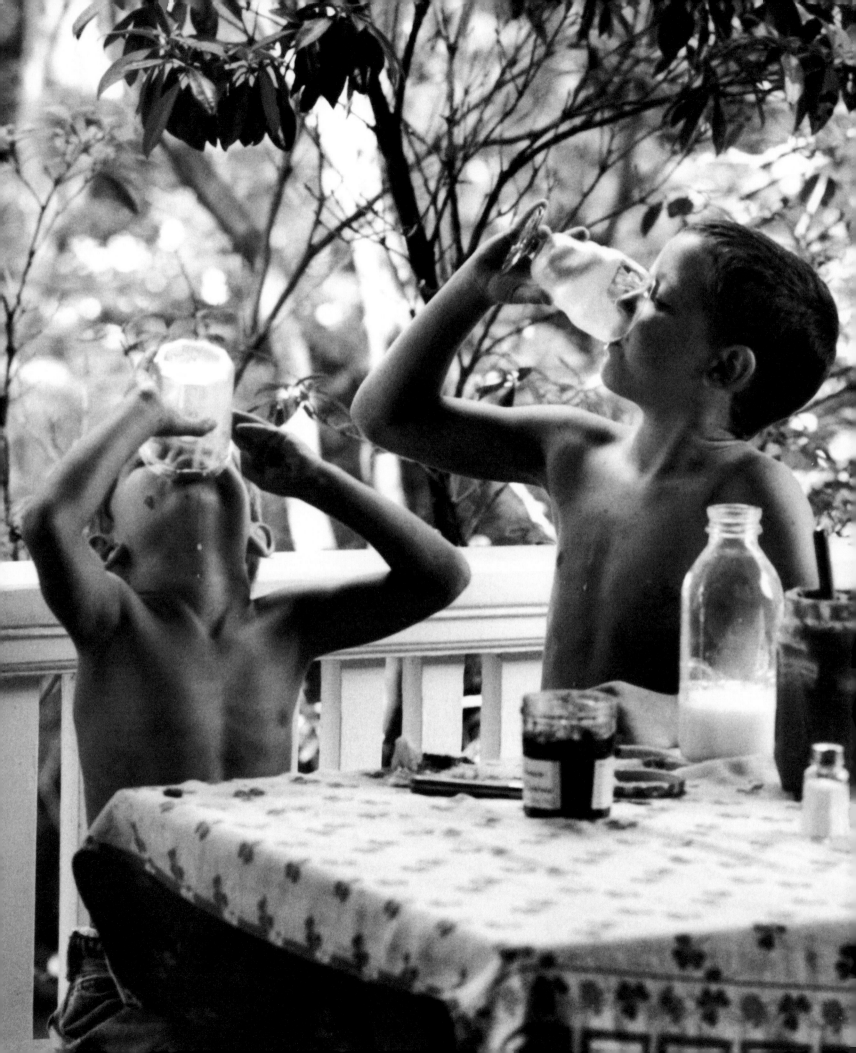

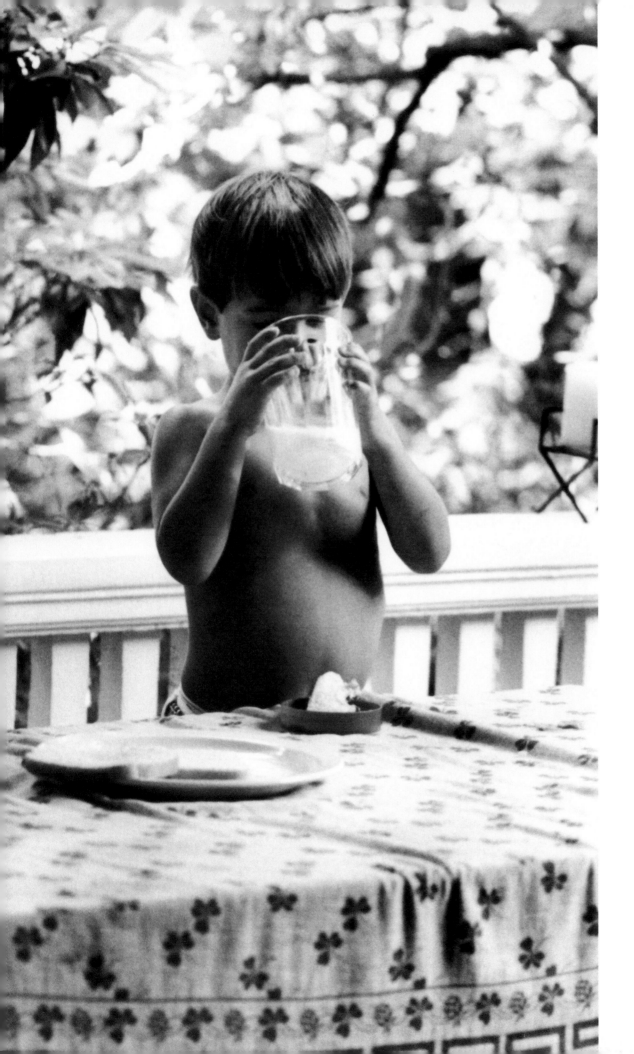

Front Porch

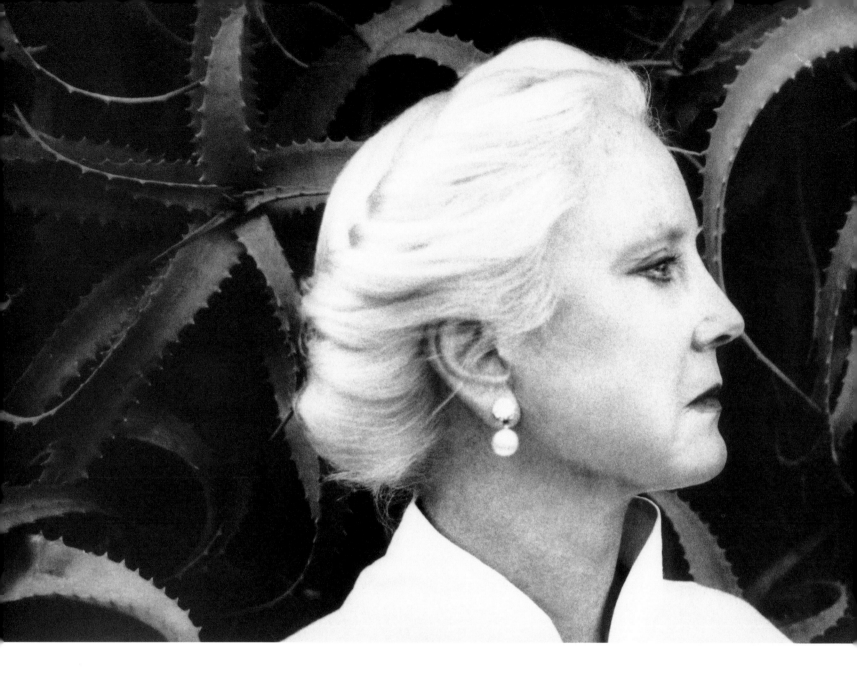

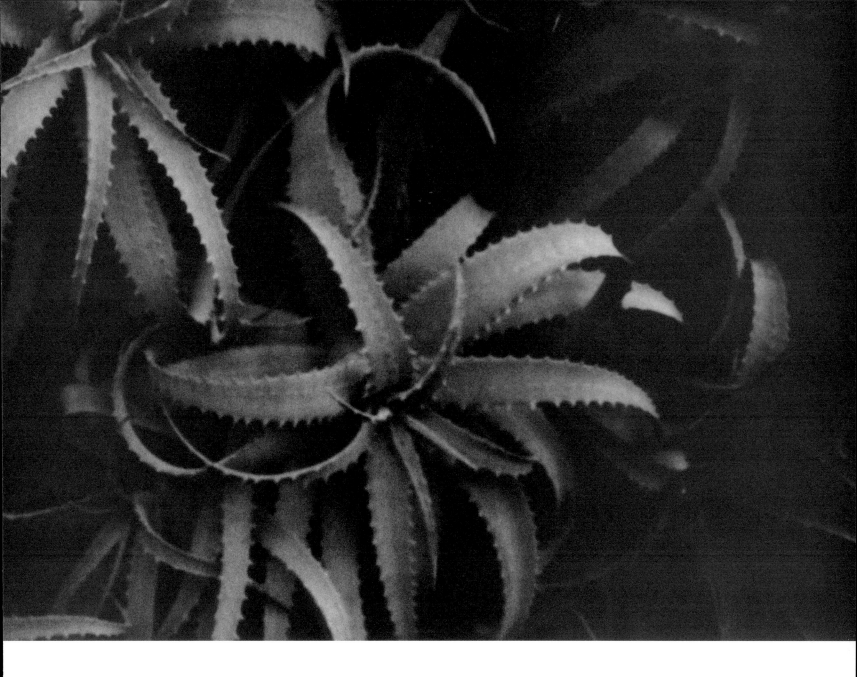

Study of Mother

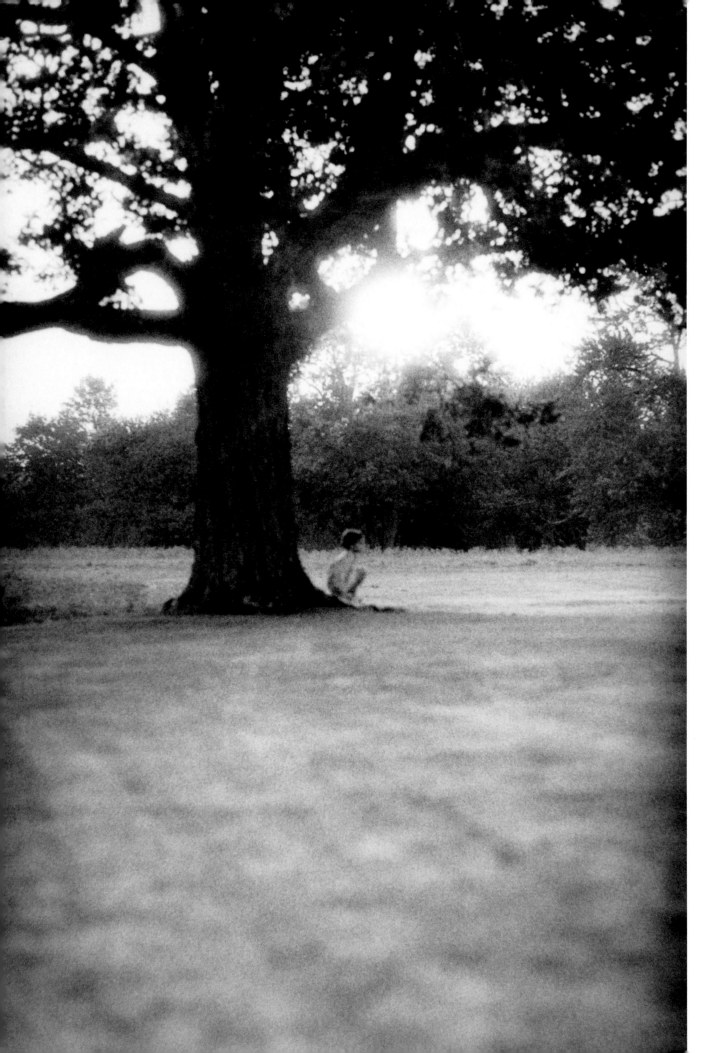

Dreamer

Catwalk

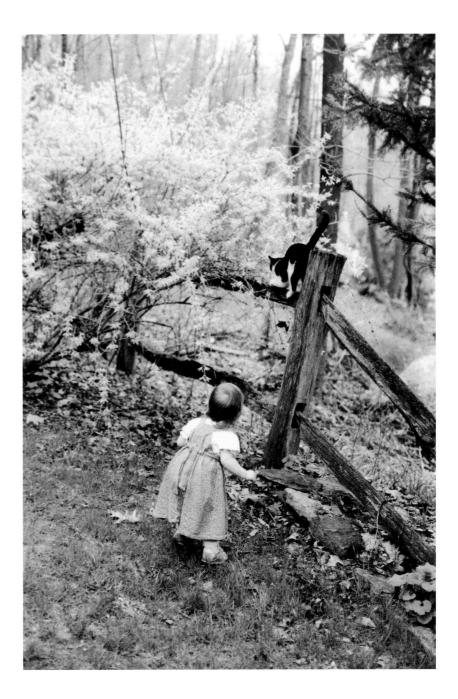

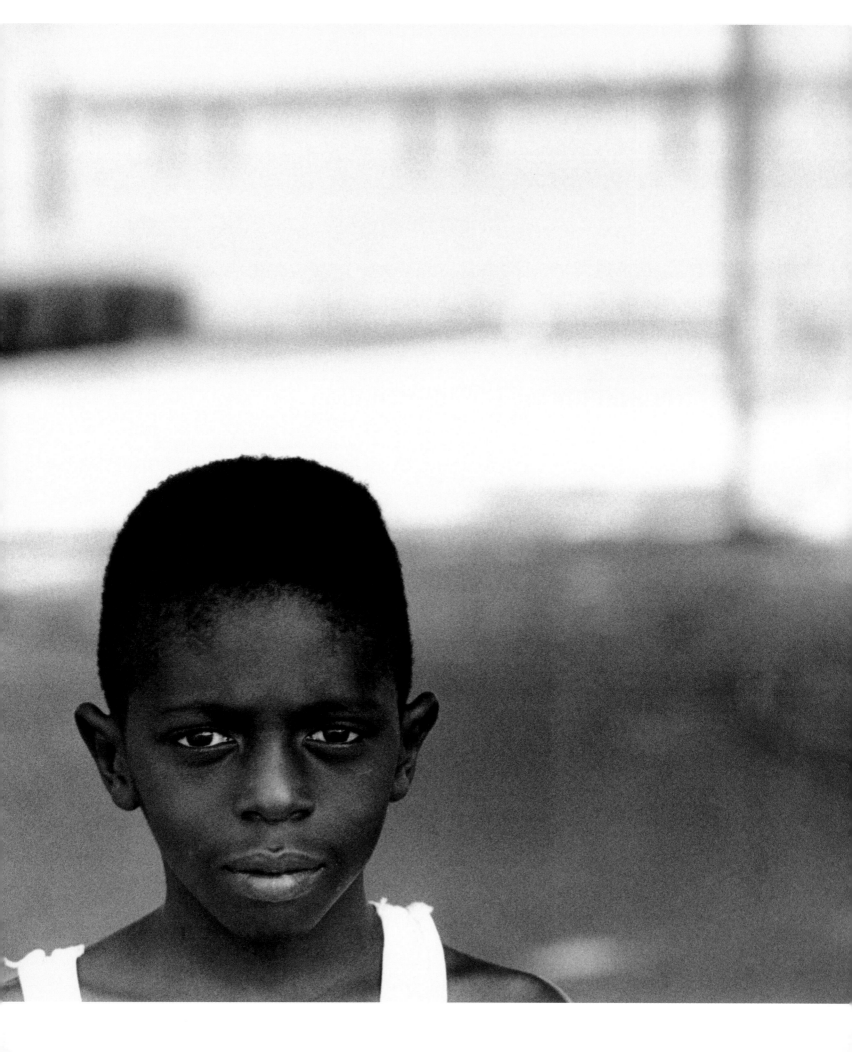

Under the Bridge

25

First Day of School

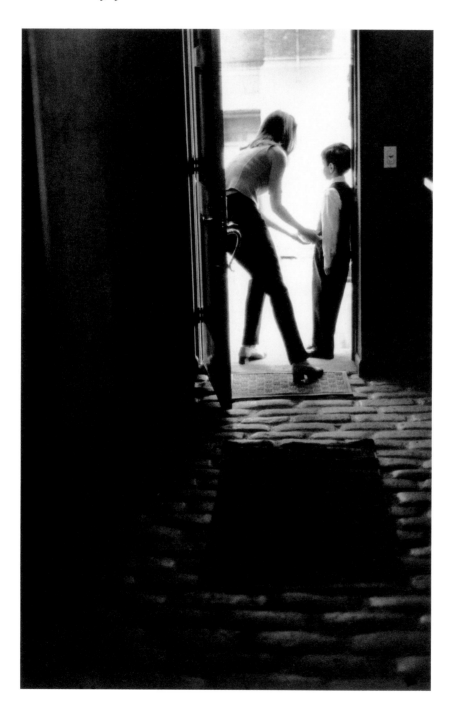

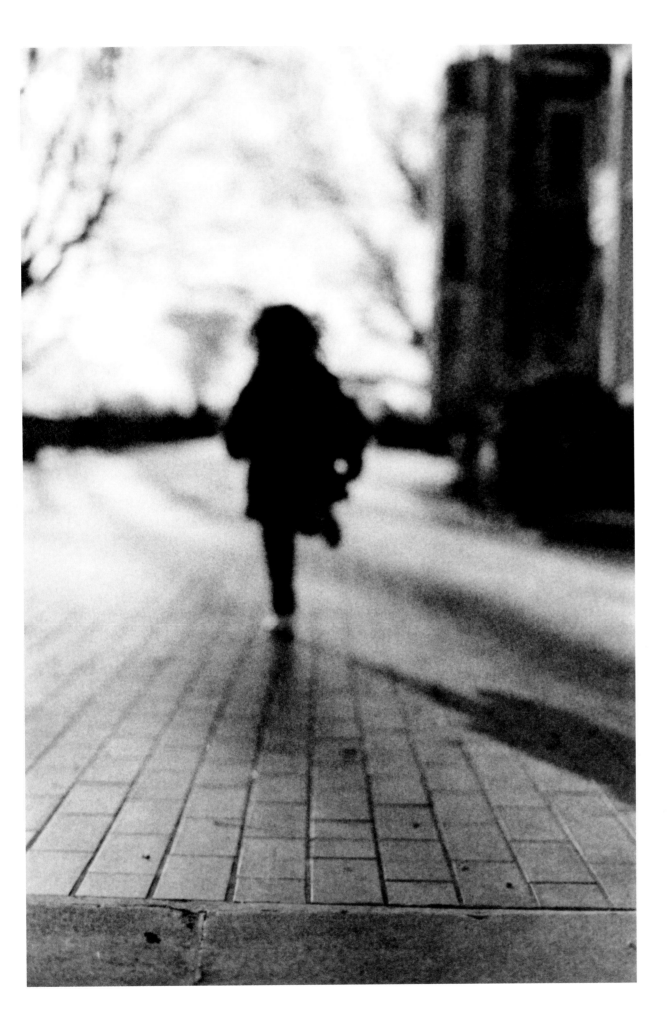

Secrets

August

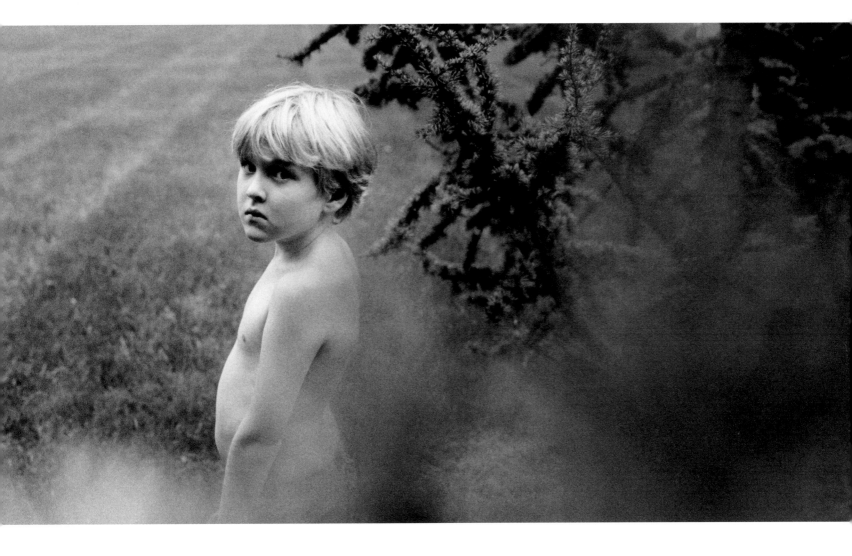

The Foot

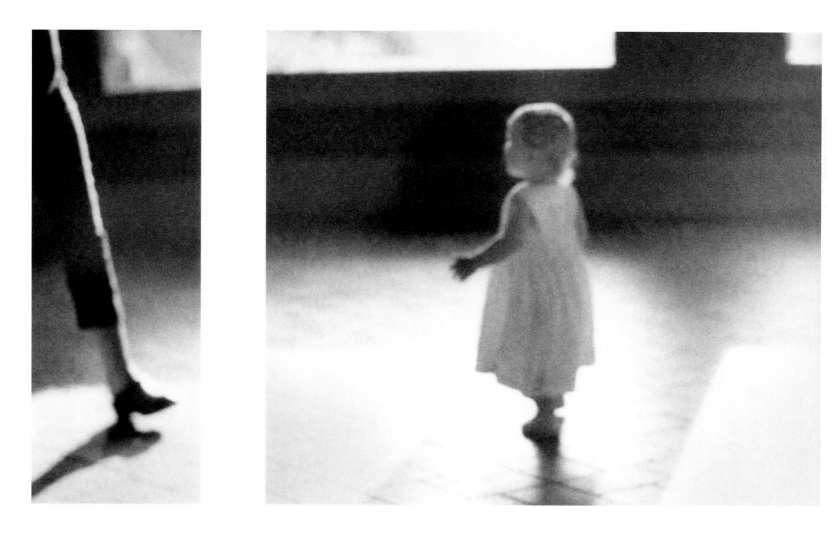

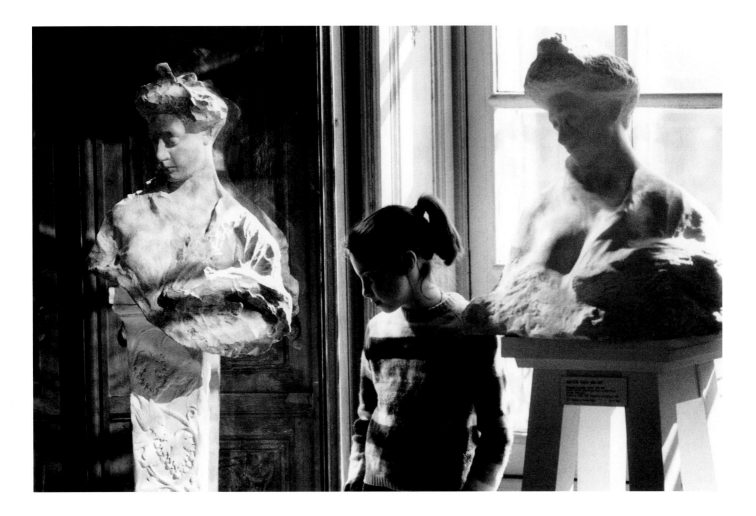

Rodin's Women

Reflection

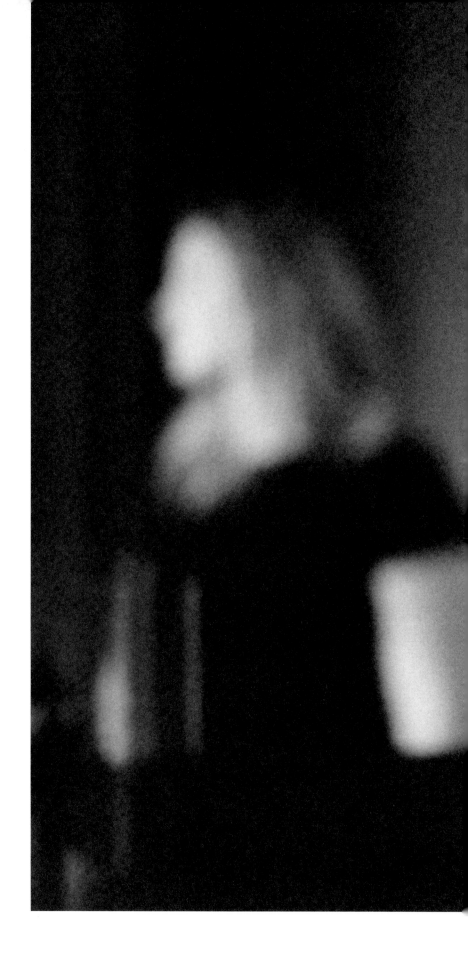

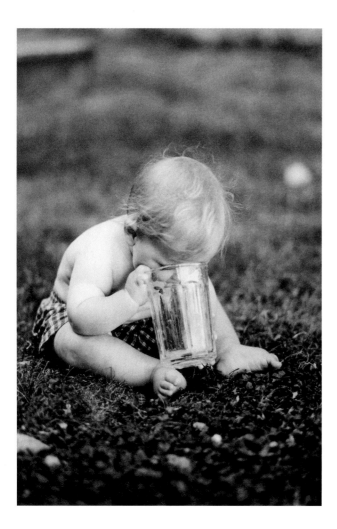

The Drink

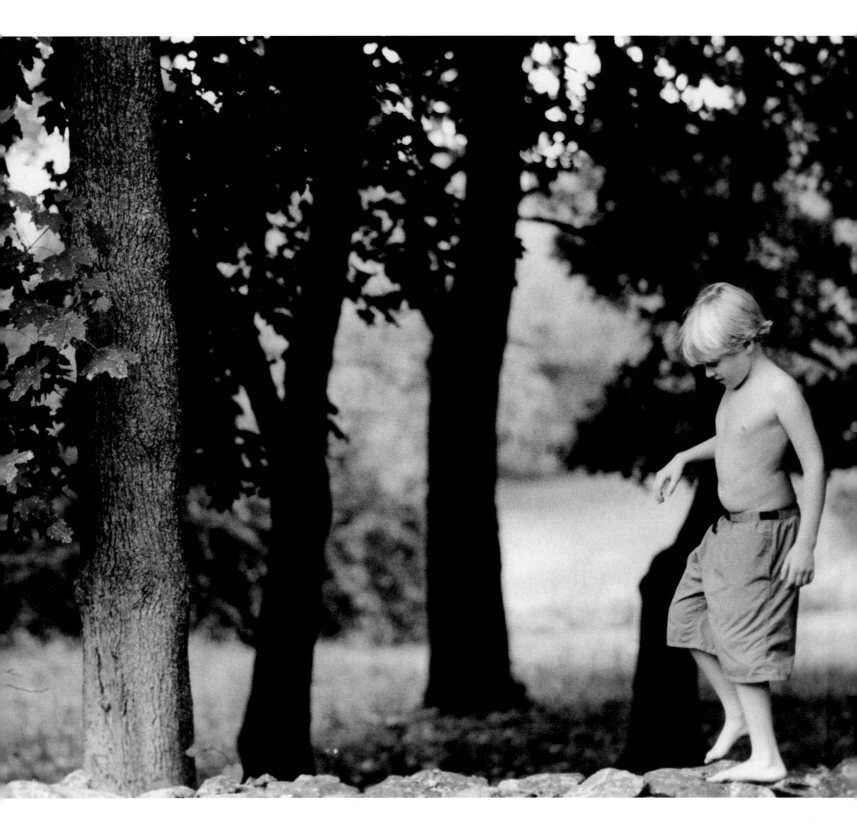

Baby Brother

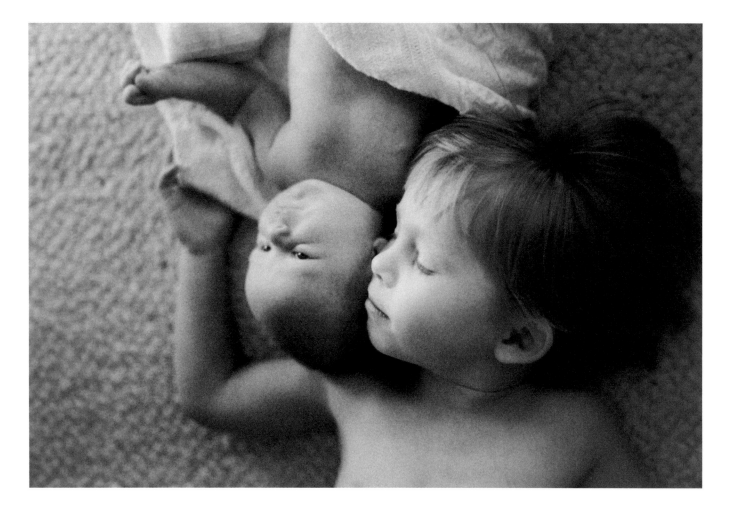

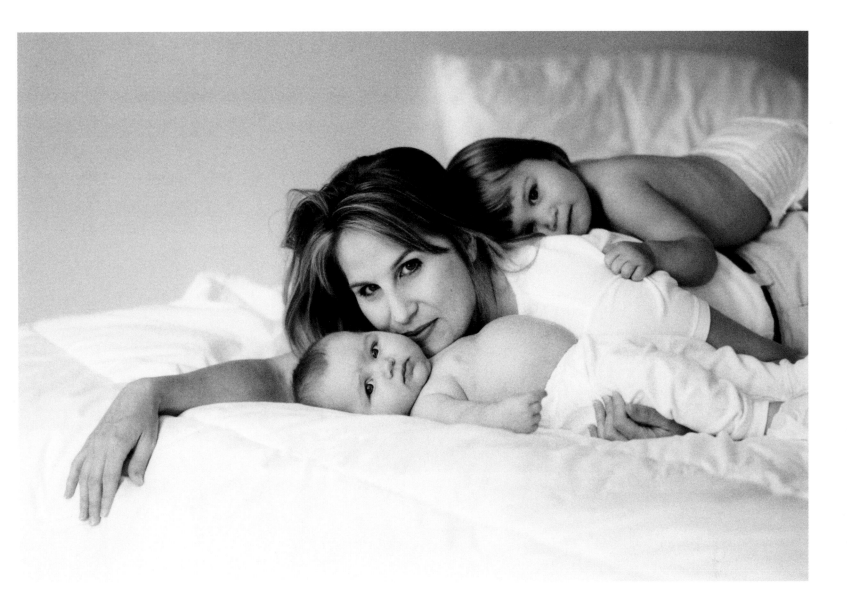

Mother with Girls

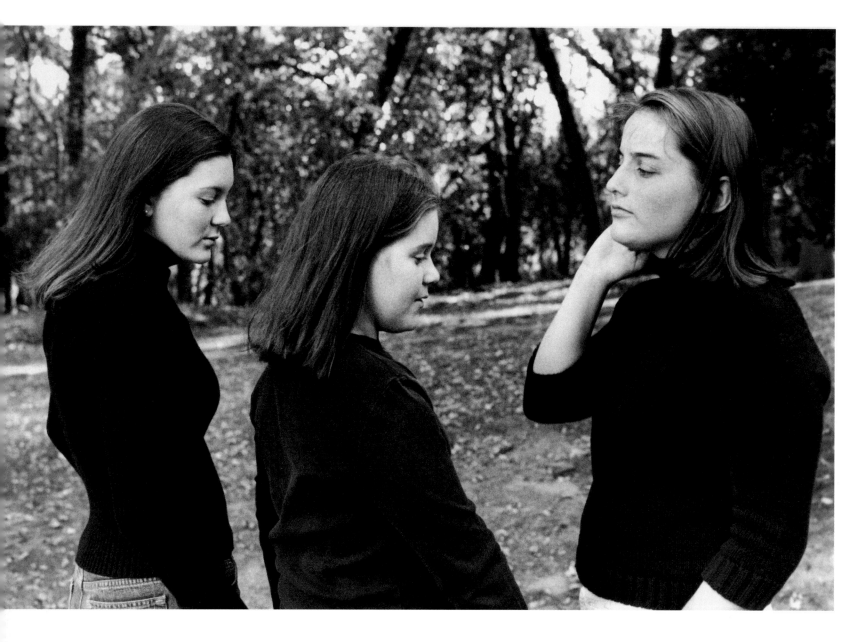

Three Sisters

Father and Son

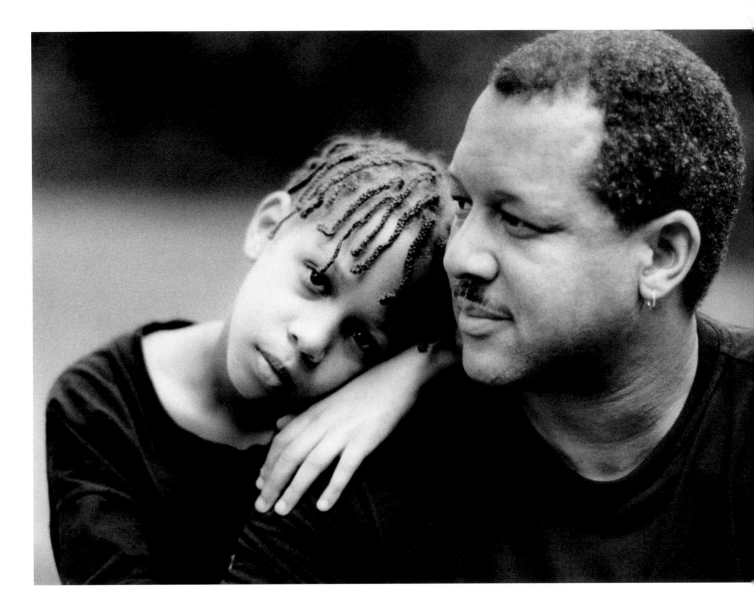

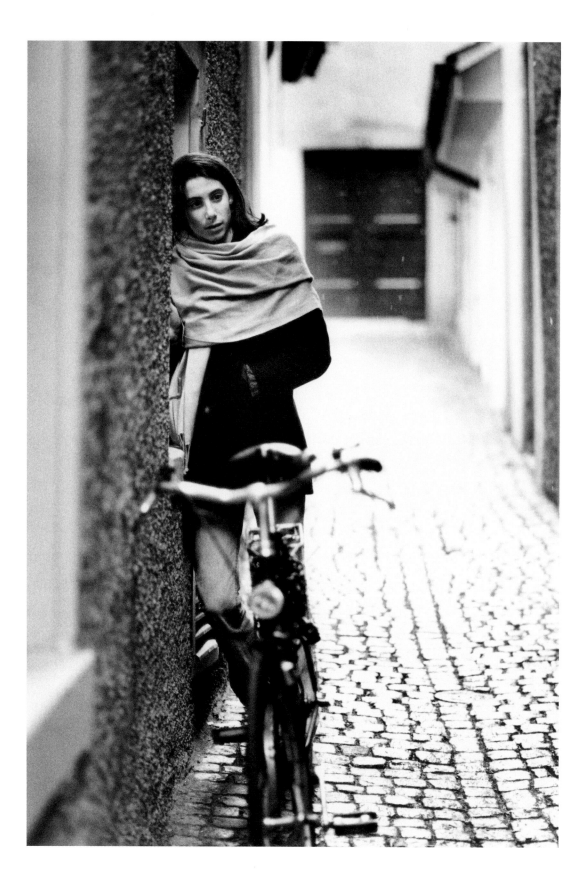

The Bicycle

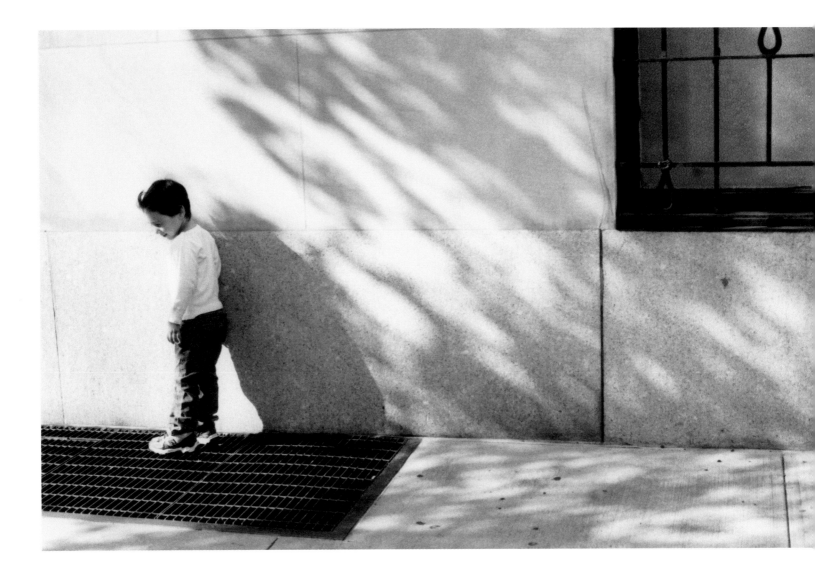

City Sidewalk

Little Red Wagon

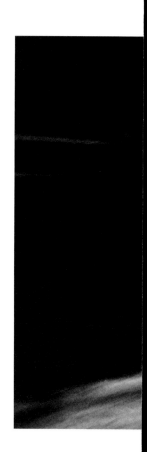

Daddy's Boy

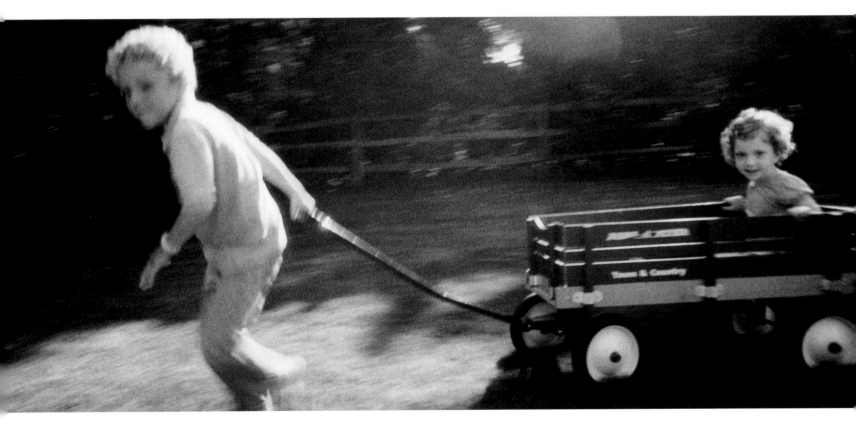

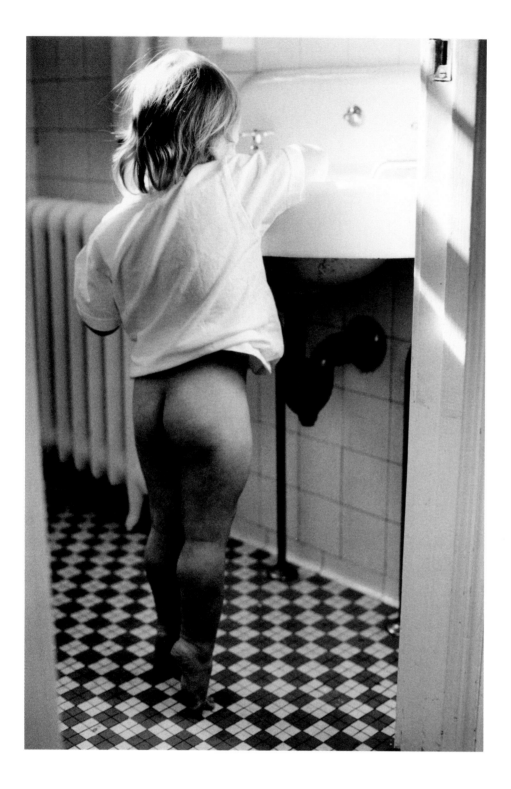

Wash Basin

Bedtime

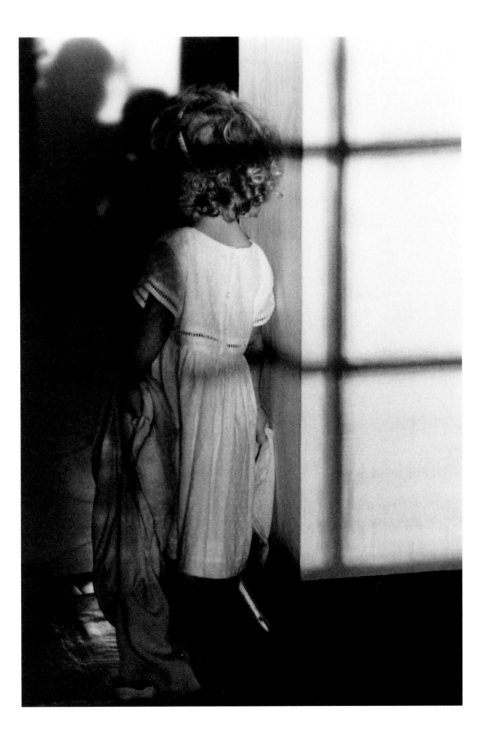

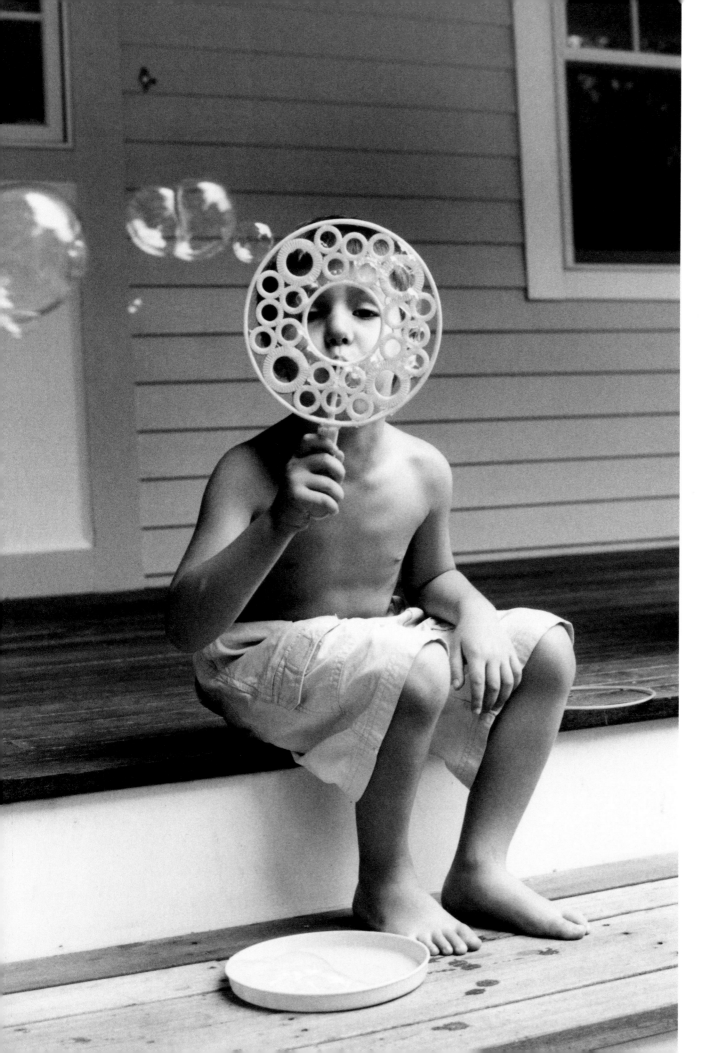

Bull's Eye

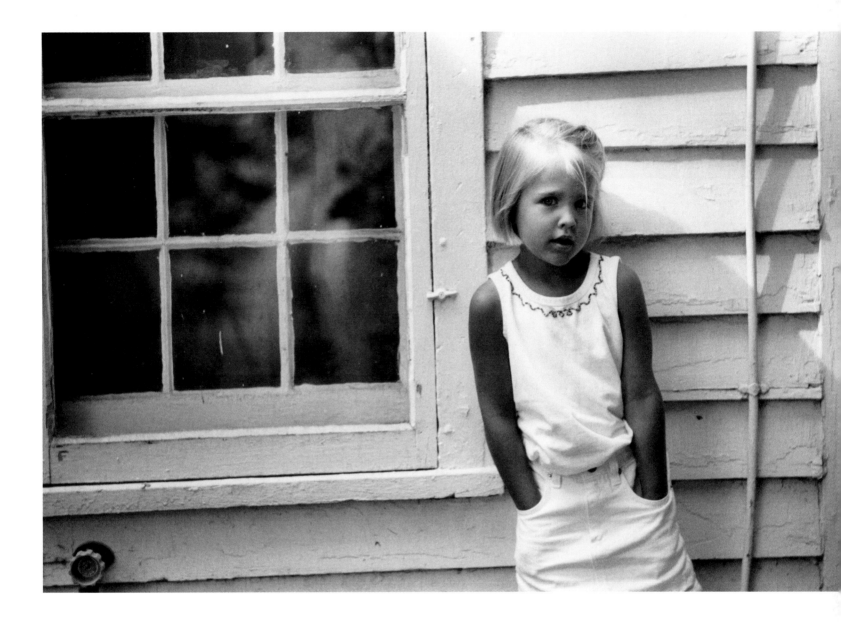

The Window

Dog with Boy

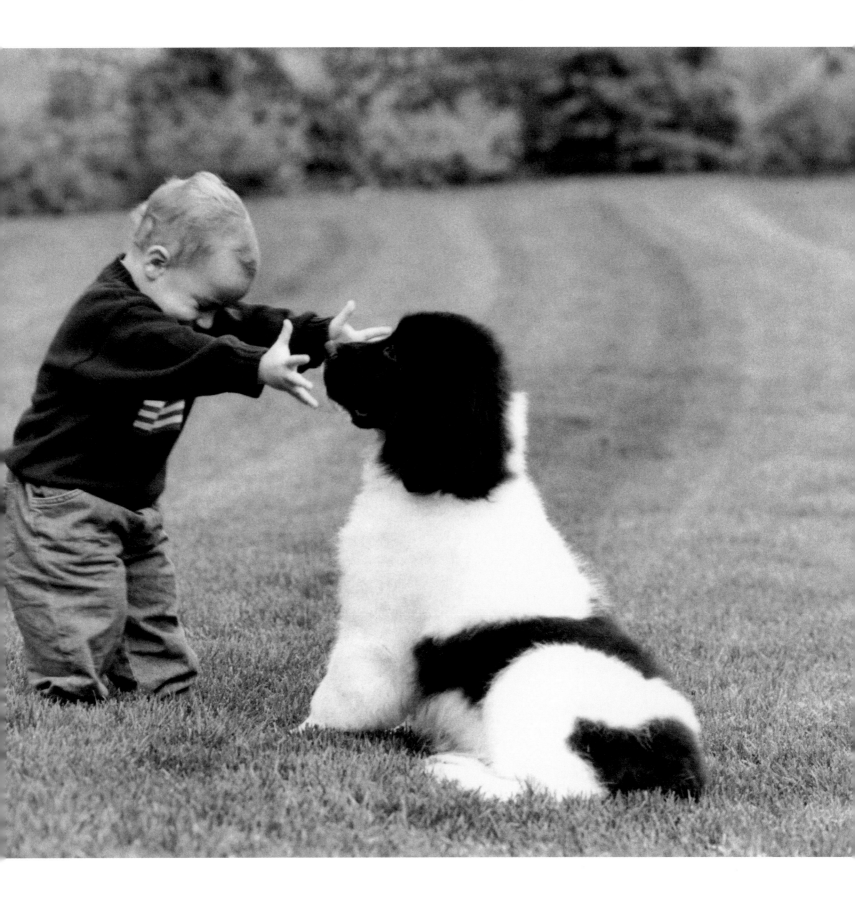

Our Angel

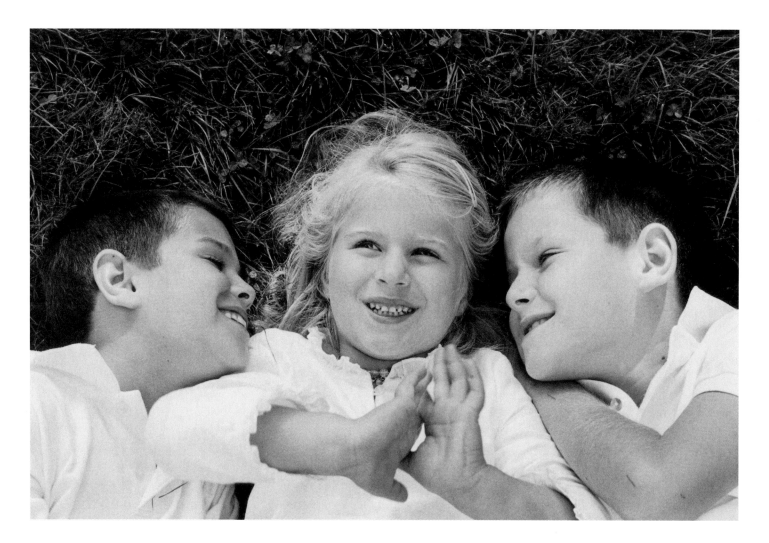

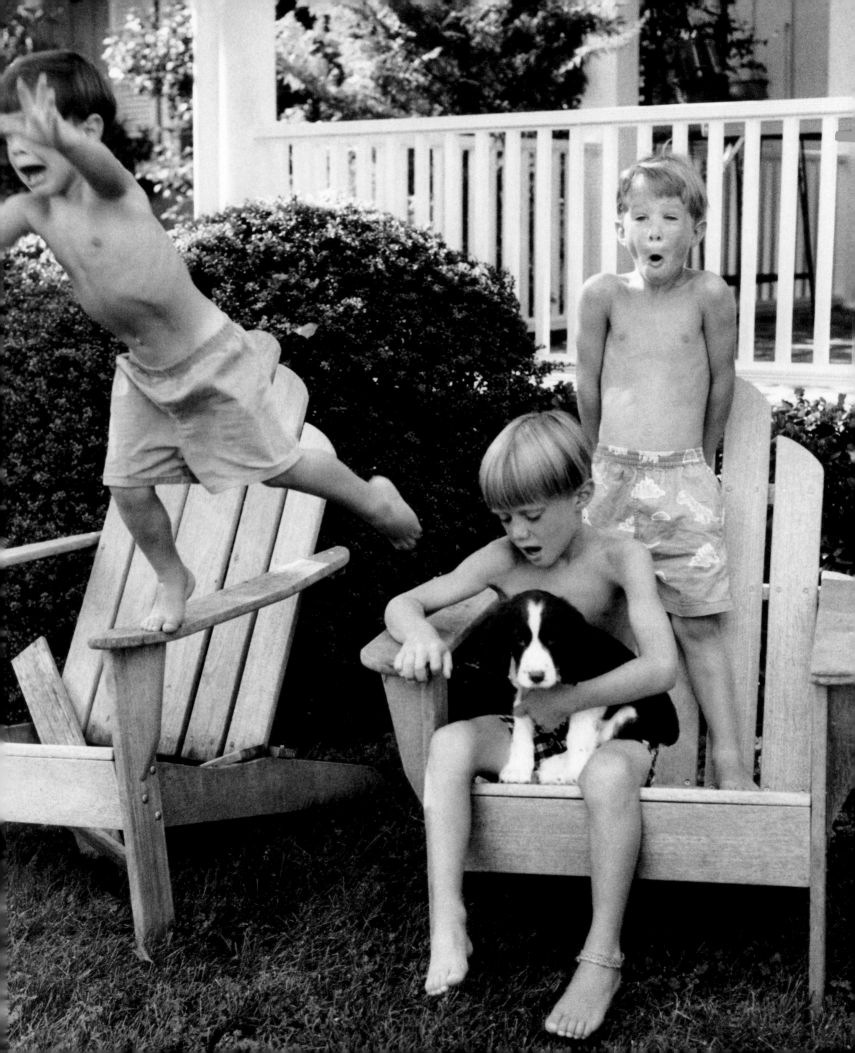

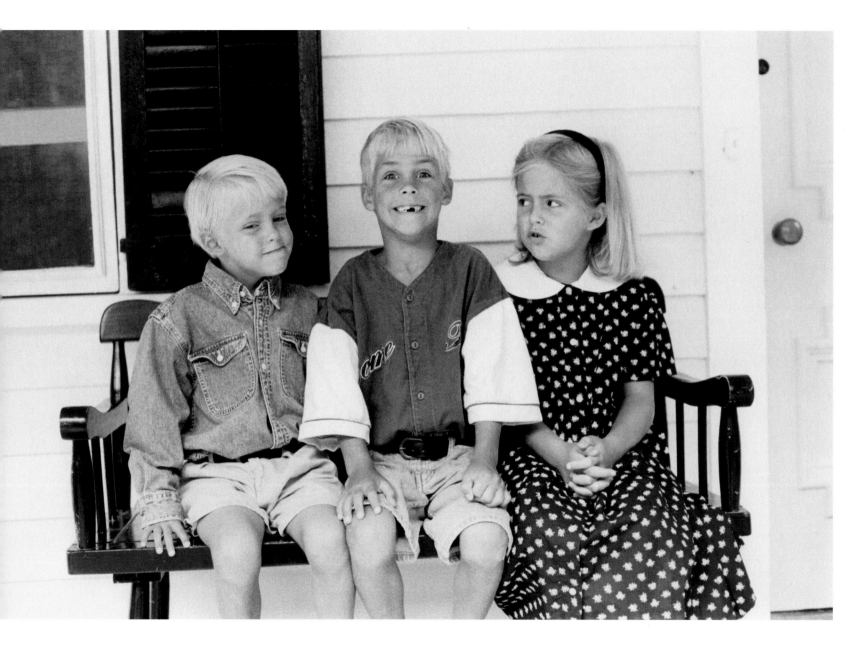

A Norman Rockwell Moment

Tomatoes

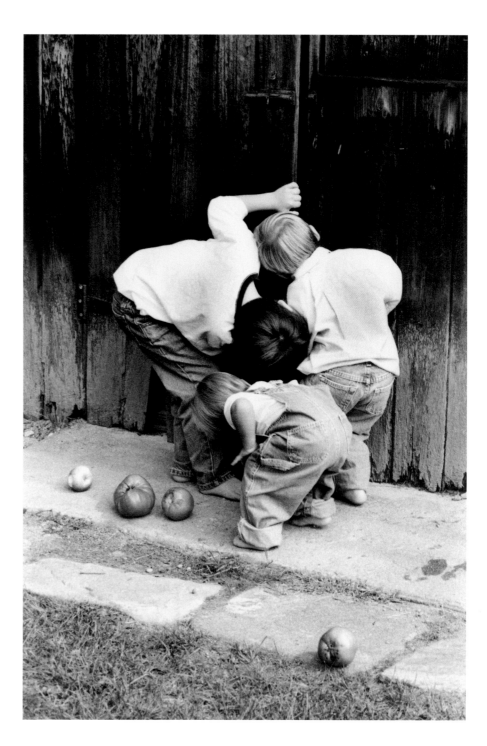

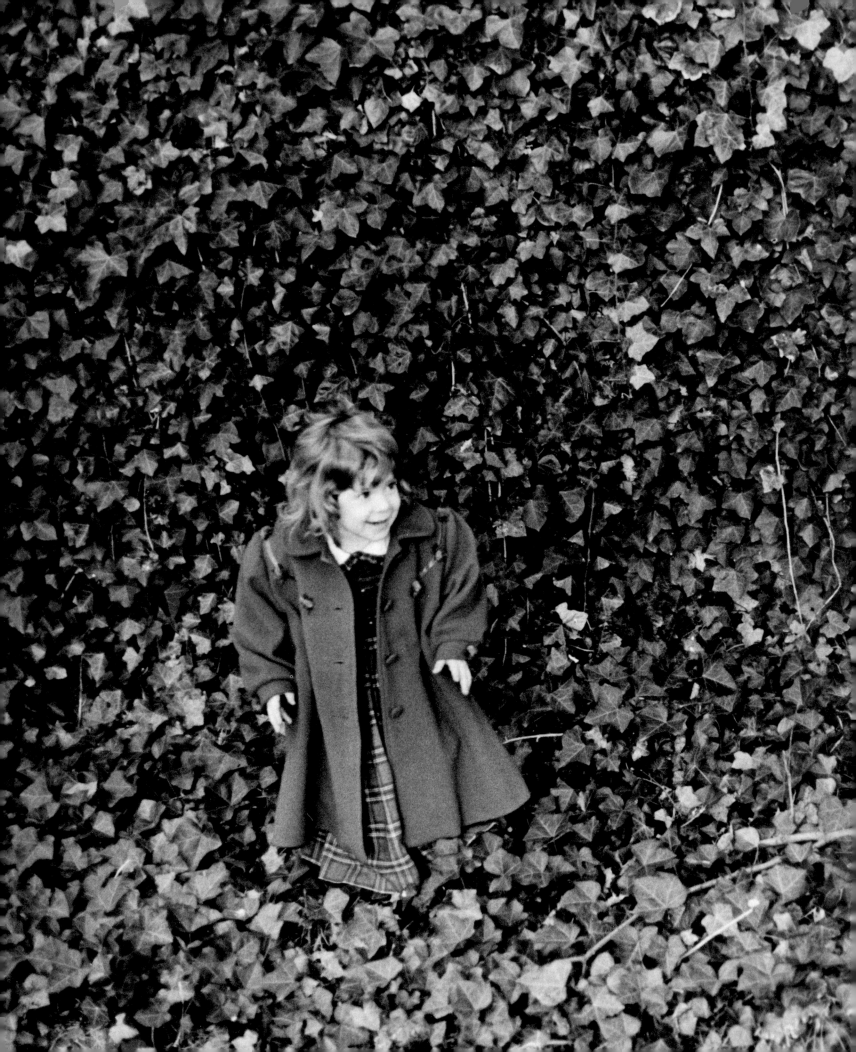

Ivy

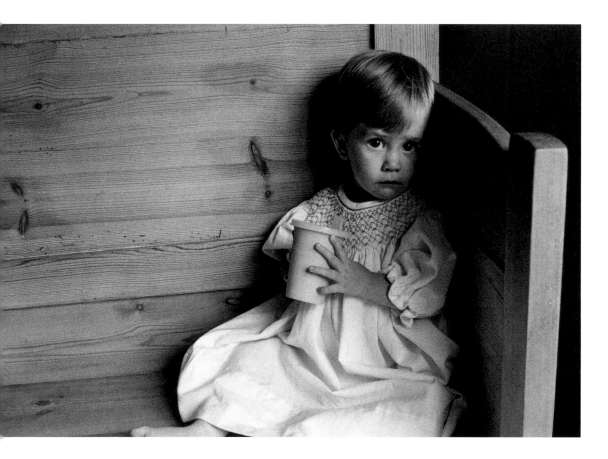

The Cup

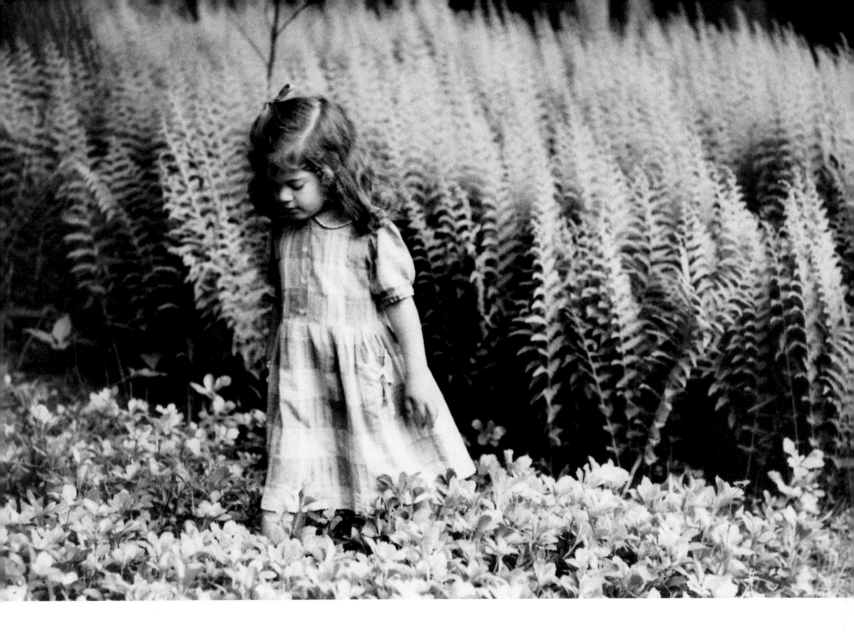

Girl in Ferns

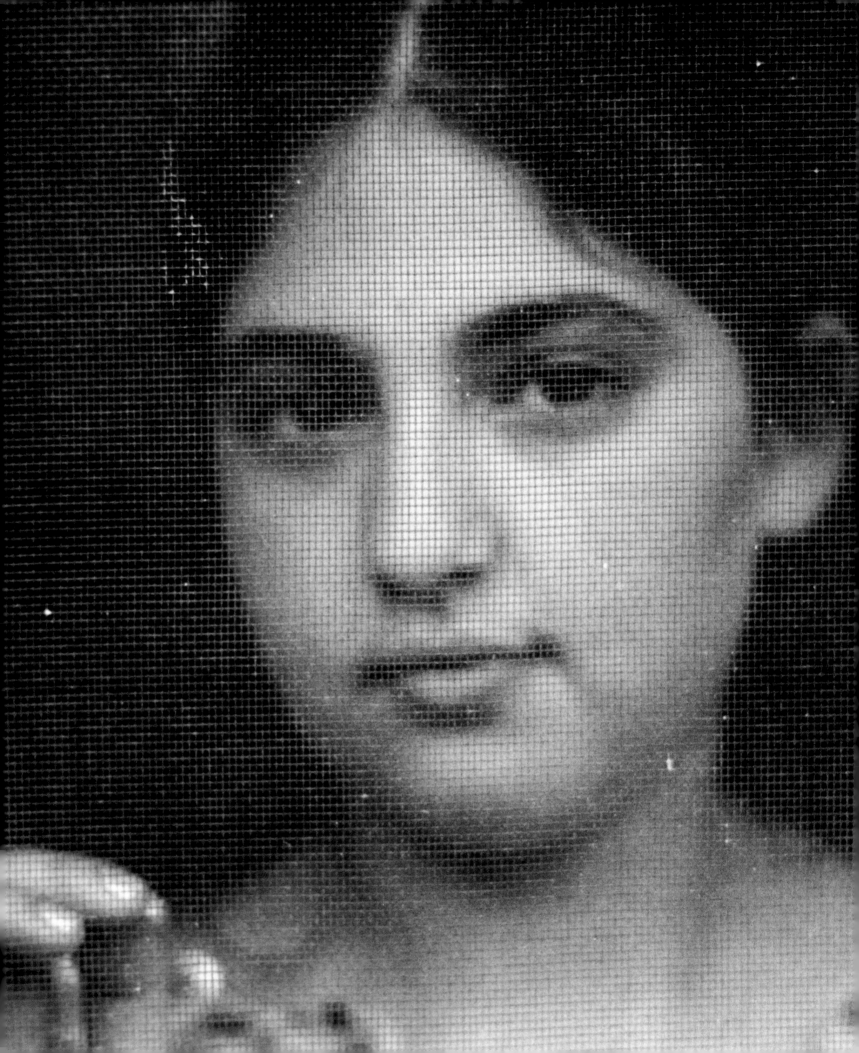

Emily behind Screen

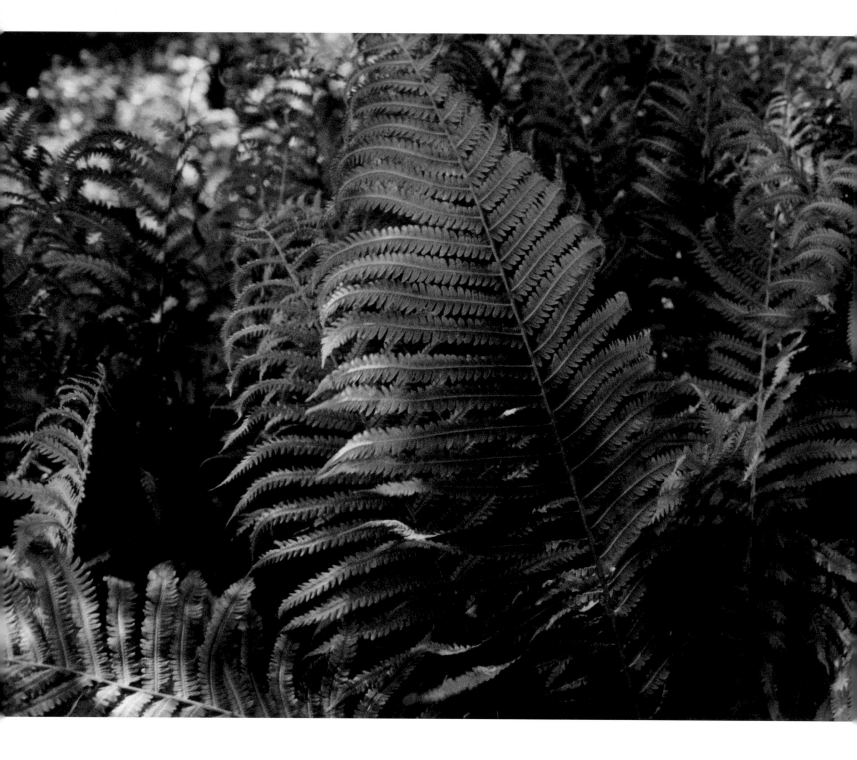

The Arbor

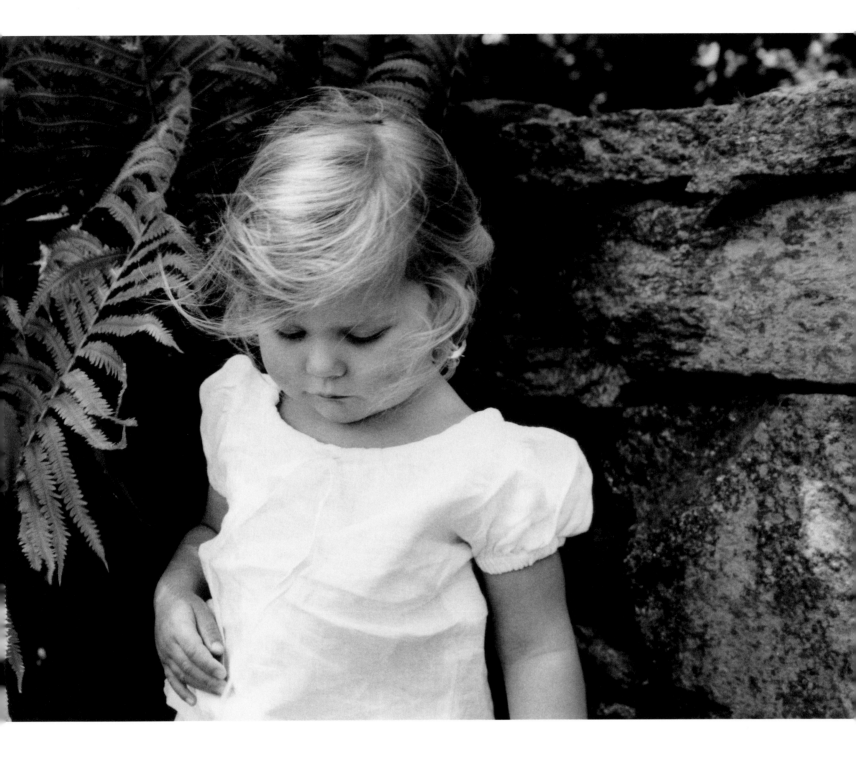

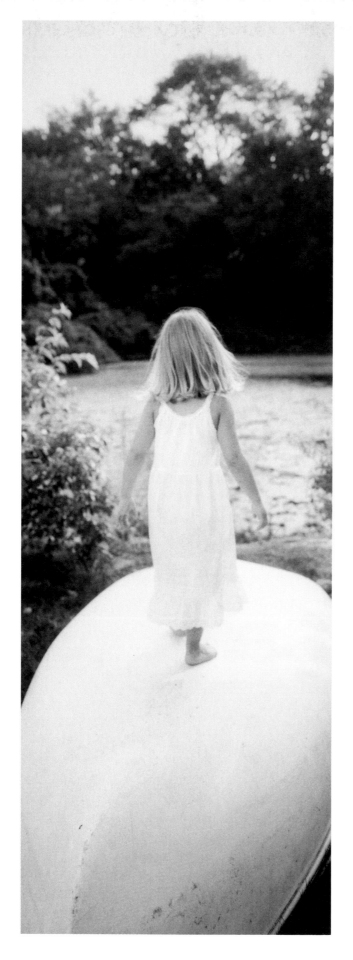

Walk on the Moon

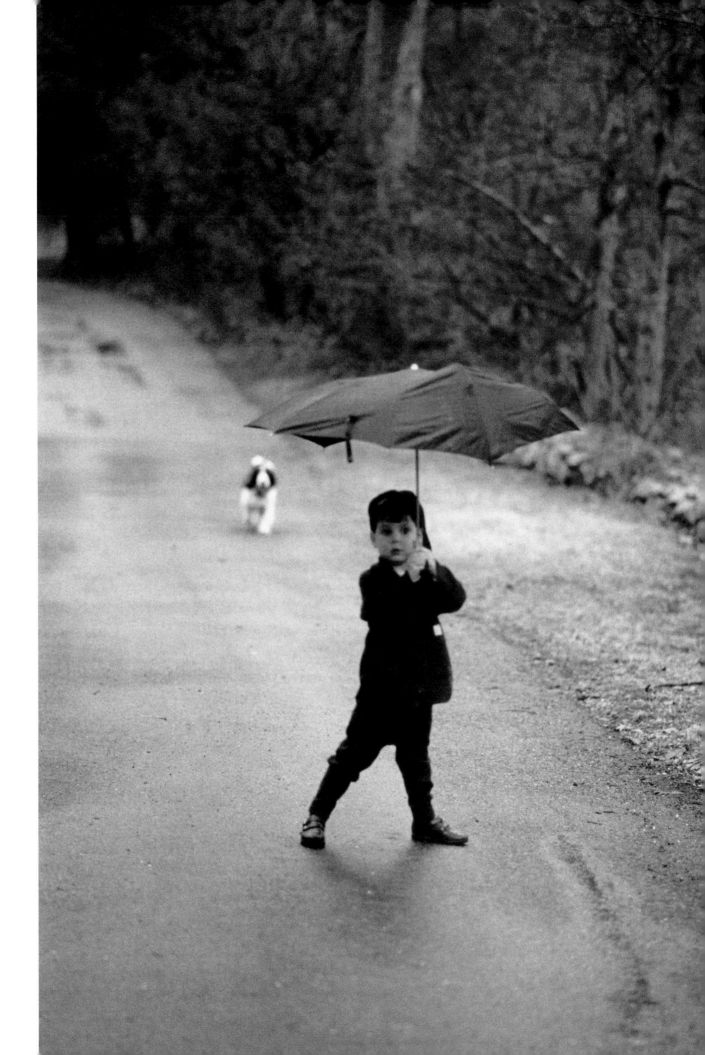

Wet Dog

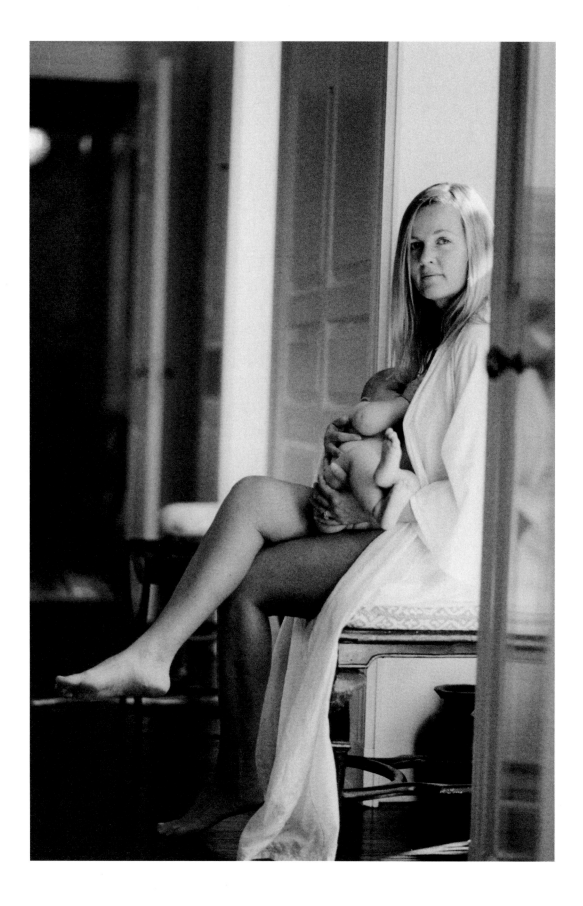

Mother and Child